Thoughts on
Art Education

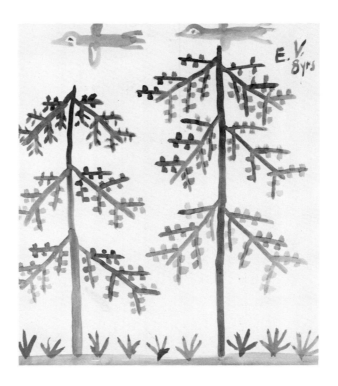

The images reproduced on the front and back covers are from a drawing of a tree by an eight-year-old child and collected many years ago by the author, Rudolf Arnheim. The tree motif was selected for the covers because it functions as a metaphor of growth and reaching outward which is a consequence of children's development in art—one of the concepts addressed in the text by Dr. Arnheim, whose background in Gestalt psychology furnishes a context for such discussion.

Thoughts on
Art Education

Rudolf Arnheim

Occasional Paper 2

The Getty Center
for Education in the Arts

Printed in the United States of America

©1989 The Getty Center for Education in the Arts

Second printing, 1991

Editor: Jeffrey Book

Designer: Kurt Hauser

Library of Congress Cataloging-in-Publication Data

Arnheim, Rudolf.

 Thoughts on art education.

 (Occasional paper series; v. 2)

 1. Art—Study and teaching. I. Title. II. Series:

Occasional paper series (The Getty Center for Education in the Arts); v. 2.

N85.A64 1990 707 89-26831

ISBN 0-89236-163-8

Contents

Preface

The Getty Center for Education in the Arts is pleased to have the opportunity to commission eminent scholars and practitioners in art education and related fields to present ideas that illuminate and inform our understanding about the value of art education.

We are proud to present the second paper in our Occasional Papers series by the distinguished psychologist and educator, Dr. Rudolf Arnheim. Dr. Arnheim has made enormous contributions to the art education field for over forty years, and the Center is honored to be able to present his *Thoughts on Art Education* as a summary of much of that work. It is our hope that the Occasional Papers will add to the appreciation of art and its significance to our lives. Dr. Arnheim's ideas on art education are an important contribution to this series.

Leilani Lattin Duke
Director
The Getty Center for Education in the Arts

Winter 1990

Foreword

For over forty years Rudolf Arnheim has provided a unique and incisive view of what humans do to create art and what art does to create humans. *Art and Visual Perception*, published in 1954, was a ground-breaking work that presented a cogent and illuminating analysis of the relationship of conception to representation. It described how, in the course of their development, children generate the graphic inventions through which the forms they perceive are reformulated within the limits of the medium with which they work. We have in Arnheim, at last, a psychologist who understands art and a scholar who cares about education. His work has been seminal to those of us who labor in the vineyards of education.

This monograph, for which I have the privilege of preparing this foreword, is, in essence, a distillation of some of the major ideas that have appeared in Arnheim's work over the past 40 years. As a result, the monograph literally is packed with important ideas. Because his language is so graceful, there may be a tendency for readers to miss the profundity of the ideas it is intended to convey. In this brief foreword I wish to identify four ideas that I believe to be of major importance for American educational theory and for classroom practice. Until quite recently these ideas have not had much salience in the psychology of learning or in theories of teaching. American psychology, particularly American educational psychology, has its intellectual roots in behaviorism. We have been mainly concerned with finding out how to shape behavior so that it approximates our goals. Our psychology has been primarily concerned with making learning efficient. As a result, it has been a psychology that has put invention, mind, and emotion on the conceptual back burner.

Arnheim comes out of another tradition: Gestalt psychology. But Arnheim's Gestalt psychology is one that is richly cognitive in character. It acknowledges the functions of mind in matters of perception. It recognizes the inventiveness through which children transform what they see into its structural equivalent in a drawing or a clay sculpture. It appreciates the connection between the form a work takes and how our nervous system resonates with that form. In short, Arnheim has given us a view of art and mind that puts art—both its perception and its creation—at the heart of the educational process. It does this not by using empty rhetoric, but by providing example. It does this through theory that is relevant to the

features of the work children create, and by relating these features to the course of their cognitive growth. There is no theoretician I know whose work has been so consistently important for those of us concerned with the quality of education and the role that art can play in its enhancement.

Let's turn now to the monograph itself. What are some of its central ideas and what might they mean for America's schools? Consider the proposition that the sensory system is a primary resource in our cognitive life. That idea is one whose time has not yet quite arrived in American educational theory. After all, our view of cognition, in the main, celebrates abstraction free from the "impediments" of sight. Following Platonic reasoning (even when we are unaware of it), we assign our garlands to words and numbers believing, as we apparently do, that words need no semantic, no referent in experience, to be meaningful and that mathematical thought does not employ structures that we can visualize. We operate on the idea that the senses merely supply the mind with data it can think about. But mind functions in the differentiation and organization of the perceptual field. In short, our educational theories, even when only implicit, regard matters of perception to be related to mindless sensation and matters of creation to the simple use of our hands.

Arnheim's work bursts these conceptual bubbles by showing us how perception itself is a cognitive event and by reminding us that the creation of images in any medium requires invention and imagination. In the course of drawing, for example, the child must not only perceive the structural essence of what he wishes to draw, which, Arnheim points out, is at the heart of skilled reasoning; the child must also find a way to represent that essence within the limits and possibilities of a medium. With each new medium a new invention must occur. That is why, for example, a tree represented through a handful of plasticine will have a very different countenance than one represented in a pencil drawing. The child invents a way to use the medium to do the job he or she wants done—and usually does it with great intelligence and economy.

If the senses play such a critical role in our cognitive life then learning how to use them intelligently would seem to be a reasonably important item on our educational agenda. Yet it takes no Sherlock Holmes to discover that in most schools the arts, subjects central to the development of the sensibilities and to imagination, are given only marginal attention. The eye, Arnheim tells us, is a part of the mind. For the mind to flourish, it needs content to

reflect upon. The senses, as a part of an inseparable cognitive whole, provide that content.

Arnheim advances another idea as well. That idea deals with the relationship of intuition to intellect. One of the limitations of language, a tool typically regarded as fundamental to intellectual activity of any kind, is that it operates diachronically, that is, the meanings language presents are strung out over time. Yet the perception of the world, indeed the meaning it has, may depend upon synchronicity—it is the field as a whole that confers meaning upon its components, and its components, in turn, contribute to the meaning of the whole. For example, to read a map meaningfully it must be perceived as a configuration, not simply as a collection of discrete units. Where a nation is situated within a continent and where a continent is situated on the globe are as important in understanding geographical space as where a city is located within a nation. Grasping the structure of a field, Arnheim argues, is an intuitive process. Intellect, the other side of the cognitive coin, is the process through which components are identified and inferences are made. The optimal development of mind requires attention not only to intellectual processes but to intuitive ones as well. Children and adolescents should be encouraged to see the whole, not only the parts.

Attention to the whole and to its constituent qualities is, of course, one of the important lessons the arts can teach. The fragmentation of content in forms that do not yield for the child a feeling for the whole are not likely to be particularly meaningful. Unhappily, too much of the teaching and curricula in our schools has this disembodied, fragmented character. Arnheim's distinctions between intuition and intellect remind us that a part without a field is without an anchor. Perceiving the structure of a configuration requires attention to the pattern or form of a whole. Learning how to seek and see such structures is a fundamental cognitive achievement.

Another major idea in this monograph deals with the relationship between differentiation and generalization. Arnheim points out that in some ways perception is something of a paradoxical process. On the one hand, recognition requires us to differentiate sufficiently to be able to identify persons, places, and objects that are significant to us. To recognize our mother, we need to see her not just as a woman, but as a particular woman. On the one hand, we need to recognize that this particular woman is not only our mother, but a woman. We need, that is, to recognize uniqueness and commonality virtually simultaneously. Furthermore, the world that we experience directly is a world in a state of change. Objects

move, the quality and light of the day alter, our position regarding what we look at is never exactly the same. Humans have the capacity to distill from this flux the essential features of a field and in so doing to give it constancy. The angle from which you view the room in which you are now sitting is not exactly like the angle from which you ever viewed it before. Yet you recognize the room to be a familiar, not an unfamiliar, one.

Tasks of this kind are relatively undemanding, but the perception of sameness in difference applies equally to more complex matters. We recognize our friend even if he or she is a block away and walking away from us. We recognize a distinctive Gestalt—we individuate our perception. At the same time we recognize our friend, we also know that we are seeing a human being, a man, and so forth. Our perception enables us to classify and to differentiate, even for qualities for which we have no label.

Much of early schooling places an inordinate emphasis on classification. Early reading calls the child's attention to the word *tree*, but it seldom calls the child's attention to what is distinctive about *this* tree. Early reading places a premium on assigning a referent to a class, the class represented by the word the child is to learn. The arts, particularly the visual arts, call children's attention to particular qualities of the world, especially for children beyond eight or nine years of age. What is important in the arts, ultimately, is not only generalization, but individuation. What is *this* person like? What does *this* leaf really look like? What do I see for the first time when I really pay attention to my gym shoe by drawing it?

Individuation is not the monopoly of the visual arts. Artistically crafted stories and literature can also make the particular vivid, they also individuate. The problem, of course, is that so much attention in schools is devoted to matters of grammar, punctuation, and spelling—the mechanics of writing—that matters of perception and form tend to be neglected. The arts—literature, the visual arts, music, dance, drama—are our culture's most powerful means for making life in its particulars vivid. In this way the arts escalate consciousness.

If Arnheim's ideas about art and mind were acted upon in American schools, considerably more attention would be devoted to helping children learn how to experience the unique features of the world they inhabit. High on our educational agenda would be not merely looking, not even seeing, but recognizing what is distinctive about an object, a person, or a field. Put another way, schools would be as concerned with fostering perceptivity as they are

now concerned with teaching the mechanics of writing. Unless such perceptivity is developed students are not likely to have much that is interesting to write about, and unless they learn to hear the music of language, what they write is unlikely to be a pleasure to read. Attention to the sensibilities and to the distinctive is not attention to educational ornamentation, but attention to the core of education. Arnheim has provided a compelling theoretical picture indicating why such attention is needed.

Finally, Arnheim reminds us that media reveal their unique features by contrast to each other. This is an important lesson worth learning. What children, or anyone, can represent is influenced by the medium or symbolic form available. Poetry was invented to say what prose can never say. Visual images can portray what even figurative, let alone literal, language cannot adumbrate. What a child can do with a block of clay differs from what he or she can do with a full palette of color. The medium and the form one uses count; they perform an epistemological function—they help us know.

What children can convey is shaped not only by the available media, but by the skills they are able to employ. Furthermore, what they are likely to attend to in the first place is influenced by the forms of representation they will be able to use to portray what they have experienced. In short, the media and the forms of representation students have access to define the parameters of representation and influence their perception as well. If you walk around the world with black and white film in your camera, you are not especially inclined to look for color on your travels.

What are the tools, the media, the forms of representation that children have access to in schools? Arnheim reminds us that this question is not simply an implied request for pedagogical variety, but a need to cultivate various modes of thinking and to open up the avenues through which ideas can be formulated. The medium counts and one of the best ways to know just how much is to compare and contrast the messages that are conveyed through the use of different media. The emerging "revolution" in cognitive science is only beginning to discover the significance of Arnheim's early insights into the processes of cognition.

The gist of Arnheim's message is that vision itself is a function of intelligence, that perception is a cognitive event, that interpretation and meaning are an indivisible aspect of seeing, and that the educational process can thwart or foster such human abilities. He

reminds us that at the root of knowledge is a sensible world, something we can experience, and that from the beginning the child tries to give public form to what he has experienced. The shape this form takes is both constrained and made possible by the medium he has access to and knows how to use. Children are extraordinarily inventive in the ways in which they get at the fundamental structural features of a kaleidoscopic world.

What Arnheim gives us is a sophisticated view of human capacity, one that helps us understand that the perception and creation of visual art are primary agents in the development of the mind. Arnheim gives us this and more, and does it with a style that is as graceful as it is incisive. *Thoughts on Art Education* is a deep and important statement. It's well worth studying.

Elliot W. Eisner
Stanford University

Instead of an Introduction

Various experiences move men and women to give thought to the principles underlying art education. There are the artists, who are impelled by their craft to demand that the necessary skills be taught in a particular manner. They say that if you want to become a good painter or a good ceramist, you have to acquire certain techniques and you have to go about using them in certain ways. Then there are the teachers, who see artwork in the context of the total development of the young person. There are others. I myself have spent forty years telling college students about the arts by trying to make suitable works come alive on the lecture screen and by explaining as best I could how these works manage to exert their magical influence.

As a trained psychologist, I knew what the experiments on visual perception had revealed about the formation of visual images. There were rules about the organization of shape and the way in which colors influence each other's appearance. Much was known about the effect of spatial depth created on a surface and about the influences of light on works of sculpture and architecture. My demonstrations of these perceptual principles in class were supplemented, wherever possible, by small group meetings where students could convince themselves by using simple materials such as paper, wire, or pigments that the tricks performed by the teacher on the screen could be brought about by their own hands. Cut the contour of a piece of cardboard in a certain manner and you will see "figure" turn into "ground"!

Those were the elements. One could use particular properties of works of art to show how those rules of perception apply in practice. In a painting by Henri Matisse, a yellow flower gave a red tablecloth a purple tinge. In a way, however, it was not fair to Matisse to use his painting in such a piecemeal fashion. It risked deflecting the students' attention from the work of art by extirpating parts of it. The artist had conceived the painting as a whole, no less than in biology the body of an animal functions by the collaboration of all its organs, and the visual whole amounted to a statement on the nature of human experience. This led me to the study of composition. There were general principles that held the elements of the work together.

Composition turned out to do more than just organize the structure of the work externally. Each of the single elements conveyed meaning, but that meaning made sense only in the context of the whole, and the context of the whole came across through the formal relations of the parts. The organization of the whole pattern was not just a more or less pleasant ornament but a symbolic image of how the artist saw the world.

Context also led beyond the single art object. It connected artworks in time and space. In the *oeuvre* of a particular artist, each work was a link in a coherent sequence. Such development could be studied in its least distracted manifestation by looking at the drawings, paintings, and sculpture of children. An almost biological growth from the simplest original shape to highly complex patterns revealed the underlying theme of mental evolution—a history overlaid with a multiplicity of psychological and social agents in the work of the child and the adult artist.

Another extension of those primary observations made me realize that a particular medium reveals its character only by comparison with other media. In my teaching, this became the occasion for an enjoyable course of study in the comparative psychology of the arts, for which I was able to assemble students specializing in studio art and art history, architecture and music, dance and poetry, philosophy and psychology for weekly discussions of readings taken from the various areas. Among those readings there was the book *On the Musically Beautiful*, written around 1850 by the Viennese music critic Eduard Hanslick, and the chapter on music in Susanne Langer's *Philosophy in a New Key*. There was Sigmund Freud's early essay on "The Relations of the Poet to Daydreaming" and the spirited challenge of psychoanalysis by the English art critic Roger Fry. We read the comparison between Homer and the Book of Genesis in Erich Auerbach's *Mimesis* and the chapter on the symbolic quality of houses in the French philosopher Gaston Bachelard's *The Poetics of Space*. These discussions invited budding architects to discuss dance theory with dancers, and musicians to sample pictorial expression. The philosophers had to step beyond the safety of abstract assertions. Conducting these classes took everything I had ever learned and thought about art and music history, about psychology and philosophy.

Those were some of the way stations of my journey as a teacher. But actually they were only the external manifestations of the basic experience from which they all derived, namely, a growing awareness of the nature of the human mind and of the nature of art. I

had realized at an early age that the study of the mind in its relation to the arts would be the subject of my life's work. To this end, scientific psychology had to be supplemented by what philosophers and novelists had observed about human motivation and cognition. There was no other access, I thought, to a theoretical understanding of art and artmaking.

These studies were happily furthered by the experience of art. From childhood on, I was used to visiting the great museums of Berlin. The limestone bust of the Egyptian queen Nefertete and the biblical tales of Rembrandt occupied my imagination, and I knew that they would continue to do so. Drawing caricatures and drawing from nature were favorite pastimes from the beginning, and as recently as four years ago I took two semesters of life drawing at the art school of the University of Michigan. During summers I spent many afternoons taking leave from my writing to carve figures in wood gathered on the beach or cut from shrubs and trees. More recently I have been doing watercolors outdoors.

Even so, I was not meant to invent and create great images myself but rather to contemplate them in the work of others and to think about them. The task outlined itself ever more clearly: I was to approach the principles underlying the making and receiving of art without losing the direct acquaintance of perceptual experience. In all those years I have never been able to consider a piece of theory nor to talk and write about it without having a concrete example in my mind. Yet theory it has always been, even when I dealt in detail with individual works.

All this is my way of introducing the readers of the present essay to what they can expect and what not to hope for. Although much of what I am saying is geared to the needs of art education at the primary and secondary levels, my view concerns the subject matter as a whole. My own teaching experience is limited to college work. Some essential features of art education show up most clearly in examples taken from that level and from art schools; but all of them apply as well, under somewhat different conditions, to what is relevant for the early grades and high school. In addition, I have gained much experience by working with teachers, and I have profited from studies in the field of educational and developmental psychology.

Essentially, however, what I have to say does not limit itself to classroom practice but refers to the very fundamentals of the mind and of art—the sort of principle that comes up rarely in daily discussion but that underlies all the specifics of learning and teaching. I am dealing

with the extracts of a long experience that, I believe, deserves not to be neglected. How successful my attempt will have been, I cannot predict. Perhaps it will leave the practicing educator with nothing better than a piece of reading that, as Jean-Jacques Rousseau said about his own writing in the preface to *Emile, or On Education*, will be too bulky for what it contains but too skimpy for the subject it discusses.

Vision and the Need to Know

S tepping back to the very base, we are reminded that organisms differ from rocks and rivers and clouds by being made up of contrivances that serve the purpose of survival. Foremost among these devices are the organs of sensory perception, by which the living creature responds to the resources offered in the environment and detects the dangers to be avoided. But actual organs of visual orientation are not yet available at the early stages of evolution. Flowers and leaves manage to turn toward the sun without the benefit of eyes. Simple animals such as barnacles are equipped with sensitive spots that allow them to discover when something blocks the light—an enemy perhaps, whose approach calls for automatic withdrawal into the protective shell. The mere distinction between light and darkness is nothing better than a binary response, but it may make the difference between life and death. As evolution refines the creature, the single sensitive spot develops into an ever richer mosaic of such spots. The more complex the mosaic of the retinal receptors, the more particular become the images of the objects the creature can distinguish, and lenses distribute ever finer details to the appropriate places on the receptor surfaces of the brain. The retina of the human eye contains some two hundred and fifty million such receptors.

But it takes more than refined images to get beyond the elementary alert system of the barnacle. In fact, the very refinement of the images creates a fundamental problem for survival because it threatens to make the world look like an assortment of infinitely many individuals, each different from the other. To make information useful, the animal must be able to recognize that different-looking specimens may belong to the same species. It must be able to identify an individual even though it displays very different aspects. To deal with dogs, one must not only tell them apart from one another but also know what they have in common; and a particular dog seen in profile does not look like the same dog seen head on. What is needed is the ability to generalize, to grasp the common features of a variety of images. Without this ability, an animal or human being could see things but not recognize them, and seeing without recognition would be hardly better than blindness.

This simple fact may seem to be far away from the topic of our discussion. Yet it has a direct bearing on it. To appreciate the nature of representational images in the arts, one must realize first that vision always amounts to more than what is manifest in the optics and

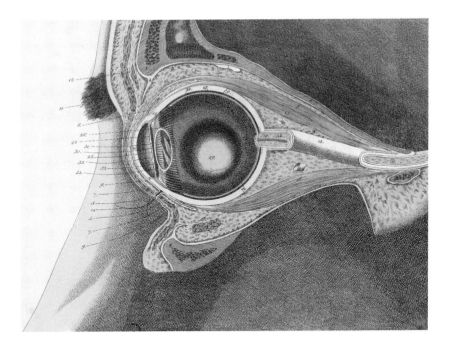

Figure 1.
Old print showing a cross
section of the human eye.
Collection of the author.

physiology of the eye. Optically, the retinal image at any moment is never more than a single
sight, and even when the message is pursued along the optic nerve to the projection centers
in the brain, its singularity persists. Vision, then, presents itself as a kaleidoscopic sequence
of everchanging images; and if one takes a careless leap from what happens in the optical
apparatus to what happens in the mind, one is led to conclude that vision is nothing but
a mechanical recording of physical stimuli.

From there it is not far to the equally careless assumption that seeing is an inferior
occupation. At best, it may seem to be the collector of the raw materials that have to be
processed by the higher functions of the mind, which generate the kind of knowledge and
understanding needed for intelligent behavior. Few human operations would seem to be
able to do without such elaboration, but are not those of the artists among those few? Do not
the painters and the sculptors limit their day's work to the creation of individual images,
images obtained perhaps from looking at a model and reproducing its appearance faithfully?
Their products may be useful and enjoyable to their fellow citizens, but must they not rank
low on the scale of human intelligence?

So narrow a notion can come about only when vision is thought of as being limited to the activity of the eyes and the projection of the optical images upon the cortical brain centers. What needs to be remembered here is that, as I noted in the beginning, all of the organism's equipment is brought about in evolution for the purpose of survival. Vision develops biologically as a means of orientation about the environment. To fulfill its function it cannot be limited to mechanical recording. It must be tied inseparably to the further mental implements of memory and concept formation.

Images Point to Essentials

I will simplify the complex process of concept formation and say that as the optical images become more and more specific, the mind processes the accumulated sensory materials in a remarkably sophisticated fashion. It succeeds in identifying persistent objects and recognizes them every time they turn up in experience. To this end, it conceives of a standard image, which is seen as embodied in every particular specimen. While a child learns to recognize the family dog, he also forms in his mind a "canonical" image of doggishness, applicable to the species as a whole.*

*(*Note*: I apologize for clinging here and there in this essay to the tradition of using masculine pronouns like "he" or "his" when I am talking about the human species as a whole. Sexism is far from my way of viewing the genders, but as a writer I must obey a rule of logic that forbids me to refer to the distinction between man and woman when I talk at a level of generality that has no bearing on that distinction. I can only hope that our language will remedy its onesidedness some time soon by presenting us with an acceptable new coinage.)

What matters for the purpose of our discussion is that all aspects of this complex process remain strictly within the perceptual realm. Specification and generalization, although contradictory, operate constantly together within the unitary process of image formation. Vision , we come to realize, deserves our greatest respect even at the simple level of someone looking at an object during the pursuit of daily life. Yet this respect has been commonly withheld when vision was thought of as being limited to the optical recording of images, while memory and concept formation were reserved to the "higher" processes of the mind. These processes were supposed to take place above and beyond perceptual imagery.

Nobody, however, has ever succeeded in discovering outside the realm of imagery a mental universe where such an activity could be located. The "unconscious," of course, is as replete with images as consciousness. Language is no mental realm of its own; it has no substance other than the meanings of the images to which the words refer. And "propositional activities" such as abstraction must necessarily rely on the one mental universe available to us—the world of the senses. To be sure, computations such as those performed by electronic devices do not need to do their own perceiving. They produce mere combinations of items, to which meaning is attributed from the outside. A computation mechanism

cannot tell the difference between airplane reservations, chess games, or medical diagnoses. Thought processes worthy of the name go beyond mere computation. Inevitably, they rely on imagery, especially on vision.

The opposite is equally true. Vision involves thinking. This also is not always recognized. Art educators, for example, will remember having been presented with the strange theory that "children do not draw what they see but what they know." The theory was meant to account for the contradiction between the style of early art and what it was expected to look like according to a naive psychology of vision. If vision consisted in the faithful recording of images, then drawings and paintings should look like attempts to reproduce optically faithful percepts. One expected the pictures to be technically imperfect, but the intention should be clearly in the direction of realistic accuracy. This, however, was not the case. Early art forms—not only in the work of children but also, for example, in tribal or Neolithic art—were composed of highly abstract geometric shapes, which were not copies of nature but responses to properties extracted from nature: the roundness of a head, the straightness of a leg. Such conceptualization, it was thought, could not occur in perception itself. It had to be the effect of an elaboration performed at a higher, nonperceptual level. Hence the absurd notion that the young mind, in dealing with the facts of reality, relies not on the immediately given resources of the senses but on nonsensory intellectual distillates.

We no longer need to struggle with so paradoxical a supposition. Once we understand vision as an inseparable aspect of the organism's way of coping with the relevant features of reality, we know that all such cognition starts with the most general aspects of things and proceeds from there gradually to images as particular as the purpose requires. For many needs of the young mind, a few broad features of things are all that is called for, and correspondingly a pictorial rendering of such elementary traits is all that needs to be given. Father and mother are sufficiently distinguished by a pair of trousers and a skirt.

Not only is such a restriction to the essentials a quality of all good reasoning, it is also an indispensable strategy because understanding necessarily proceeds from the broadest generalities to the more specific structures. By doing just that, early artwork is one of the most powerful means available to the human mind for orienting itself in the environment. The world to which the senses awaken is far from being an easily understandable place. Take as an example the confusing network of a tree. To understand a tree amounts to

realizing that the structure is organized around the vertical center of the trunk, from which the branches extend in all directions. A hierarchy of ever smaller members leads from the robust central column of the trunk to the delicate twigs and leaves and blossoms. This structure, however, is far from evident at the first glance. To discover it takes the sense of vision's remarkable shrewdness of analysis. We know from the drawings and paintings of young children that such analysis is accomplished in the early years of life. The early pictures of trees, far from being attempts at mechanical imitation, testify to the much more intelligent feat of grasping the basic structure of the plant visually and then translating this structure into the kind of shape pattern available on the pictorial surface or in a sculptural medium.

Not much value used to be attributed to such early artwork. Childish scribbles were to be left behind as soon as possible and superseded by more realistic images. We understand now that the manifestations of the mind actively at work so few years after birth deserve all our respect. Typically, they are a spontaneous activity, not explicitly guided by adults. The young mind generates the impulse to take hold of the world, to understand it, and to bear witness to its wondrous wealth. Once we have acquired the respect for this early achievement, we shall never underestimate the importance of artwork at any level of human maturity, be it in the schoolchild or in the adult artist.

In most cultures, the early abstractions develop eventually toward more realistic imagery, but only quite rarely does this development attain the illusionistic lifelikeness of Hellenistic murals or Renaissance art. It happens that our own tradition is still under the influence of Renaissance naturalism. In spite of all the exploits of modern art, lifelike images are still popular. It is a preference commonly found together with a materialistic interest in tangible things. The pleasures of good food, attractive landscapes, and the sensuous charms of nude bodies are faithfully reflected in painting and sculpture. But there are also powerful counterforces. In the service of religious spirituality, "graven" images may be reduced to the aseptic simplicity we know from Byzantine icons, or they may be entirely banned. And even where painting and sculpture are an integral aspect of the culture, as for example in ancient Egypt, a statue portraying the Pharaoh in a lifelike fashion would have been in conflict with the impersonal majesty it was intended to represent.

Highly realistic representation is required for certain technical purposes, especially in the

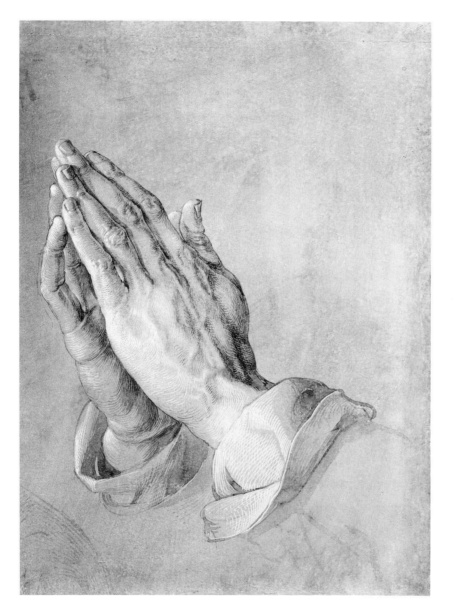

Figure 2.
ALBRECHT DÜRER
(German, 1471–1528).
Praying Hands, Study for the Heller Altar, circa 1508.
Drawing.
Vienna, Graphische Sammlung Albertina.

sciences. But significantly enough, even there more is needed than mechanical imitation. Reproduction mostly involves interpretation, and scientific or technological illustrations are useful only when they clarify certain functional properties. To this end, the draftsman uses the pictorial means of shaping, shading, overlapping, coloring, etc.—he creates a highly

organized composition, different in purpose but not in visual principle from what is done in the fine arts.

Since, as I have noted, perceiving and picturemaking are indispensable for grasping essential properties of the environment, it takes rare conditions to make this admirable mental ability deteriorate into mere copying. Our modern techniques of exact duplication may have favored such an attitude. Fortunately, the average artist remains immune to mindless reproduction. Nevertheless, it became common among drawing teachers of the past century and still survives here and there in the present to insist on mechanical correctness in producing images of the model, for example, anatomical exactness in the measurable shapes and proportions of the human body.

While the acquisition of such a skill can be useful, it tends to suppress one of the most precious responses of the mind. In the historical past, even recourse to mechanical devices did not keep good realistic artists from giving their shapes the expressive power that made their images into thoughtful statements about their subjects rather than mere replications of their physical appearance. When Albrecht Dürer drew a pair of praying hands with all their individual texture and wrinkles, he nevertheless gave their shapes a straining confluence conveying their symbolical meaning. Only recently, an anatomist testified that all the many muscles indicated by Michelangelo on his drawings of the human back are strictly correct, even though they also conform to the flow of an expressive movement—an eloquent harmony not simply read off from the model but imposed upon the image by the artist's striving toward a meaningful statement.

Models and Techniques

For some time now, there has been a controversy among art teachers as to whether drawing from models is advisable. The more "progressive" educators have insisted that any leaning on an outer guide would cripple the student's spontaneity. Others have argued that youngsters, especially those in the early teens, incline naturally to the imitation of admired prototypes. Even the copying of newspaper cartoons has not been frowned upon by some teachers.

It seems to me that the debate is wrongly focused. It is natural for much art to reflect the objects of the environment, and it does not matter whether the picture of a turtle is drawn from memory or while a child is actually looking at a pet. Young children, as is well known, will hardly look at the model anyway. They will take the barest cues and proceed to work from the standard image they have formed in the course of their experience. As long as their own sense of form and inventiveness controls the work, its educational value is unimpaired. The battle scenes and monsters of popular imagery are freely translated into the child's pictorial idiom. The teacher needs to begin to worry only when the commercial slickness of the models threatens to stifle the child's spontaneity.

In the later years, especially if some or all of the students are preparing to become professional artists, the instructor faces the task of teaching "techniques," and here again he or she needs to consider thoughtfully how to preserve the ultimate value of art activity. In a figure-drawing class, for example, the telling expression of the model's body caught in a particular pose dries up all too easily when the instructor limits himself to discussing measurement, exactness, proportion, or anatomy, as though the task consisted in producing a physical duplicate of the model. Instead, students should be asked to become aware of the particular expression they see embodied in the stance and gesture of the model—a proud uplift, an aggressive tension, a lazy surrender—and to discover what shapes carry the observed attitude. In the struggle to capture and render those meaning-carrying features, the students have ample opportunity to train the techniques necessary for producing the exact shapes that convey the desired effect. They will realize at the same time that faithful duplication is only one among the many objectives one may choose to pursue.

A similar approach is indicated for the teaching of any specific technique, such as the

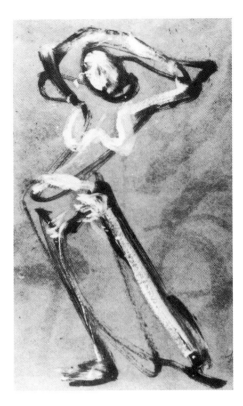

Figure 3.
Student Gesture Drawing
from *The Natural Way to Draw*
by Kimon Nicolaides.
©1941 by Anne Nicolaides
(copyright renewed 1969 by
Anne Nicolaides).
Reprinted by permission of
Houghton Mifflin Company.

geometry of central perspective. All too often, perspective is presented as an isolated set of tricks. No attempt is made to introduce it with a discussion on why one may want to create a sense of the depth dimension and which are the various ways of obtaining it. It should be made clear that the particular system of Renaissance perspective involves a violent distortion of the shape and size of things and therefore has been resorted to only under very special cultural conditions. The student should also be made to realize that the picture of a world converging toward a center presupposes a very particular psychological and social conception, not suitable for just any worldview; and finally that from its beginnings in the fifteenth century artists have taken considerable liberties with the rules of perspective because they were after certain spatial effects rather than strict obedience to geometrical rules. In sum, perspective is not simply a precious acquisition, valuable and suitable whenever received, but a special device to be resorted to when a well-defined need calls for it. Introduced at the wrong stage of training, it can be an impediment rather than a help.

The Values of Expression

While discussing some practices of art and art education I may seem to have slipped beyond what I described in the beginning as the biological usefulness of sensory perception and imagemaking. Those activities, I said, serve to let us cope with the confusing abundance of the experiences that overwhelm us as we are born into this world. Learning involves not only the identification of individual instances but also and mainly the shaping of types of things and the discovery of their properties and functions. These psychological needs are beautifully served by the arts, which is one of the reasons why the arts have been indispensable to all civilizations we know of.

Then, however, I stressed the value of visual expression, meaning such qualities as the proud erectness of a human figure, the upward-striving of a tree, or the playful skips of falling water. The importance of such qualities is much less obvious than that of the information and concept formation just mentioned, and when it comes to deciding what facts young minds should be concerned with, these qualities may not seem to deserve any priority. A perfectly useful life, it seems, can be led without concern for "expressive" values. In fact, at times they have been condemned as mere indulgence in pleasurable sensations. Such low esteem has been supported by the particular terminology used by people in the arts to describe the nature of paintings and sculpture as well as that of the products of other media such as music, dance, and poetry.

Art, it is commonly said, expresses "emotion" and is produced through and by emotional states. It is due to "feelings" and conveys feelings. Now in common usage, the terms emotion and feeling do not enjoy a high reputation. An emotional person is one given to irrational impulses, a person who reasons badly, and feelings, more often than not, connote a vagueness of cognition: a person who does not know for sure relies on mere feeling. No wonder that an activity based on emotion and feeling arouses suspicion.

I am convinced that these terms are unhelpful even in general psychological theory. What is generally meant by "an emotion" is actually a conglomerate of three components: an act of cognition, a motivational striving caused by cognition, and an arousal caused by both. Suppose that on a walk you meet a reptile you recognize as a poisonous snake. This act of cognition produces in you a motivational drive to escape, and the intensity of the event makes

your heart beat faster and your lungs pump more deeply. Obviously, only the third component represents the particular mental quality to be appropriately called "emotional"; the first two are misinterpreted by being put under this heading. In consequence, any experience called "an emotion" is falsely described by a merely secondary manifestation, not to mention the fact that every human performance of some complexity contains all three components, be it the solution of a puzzle, an astronomical discovery, or a business proposition. In other words, either human behavior consists of nothing but emotions, or there are no emotions at all!

By correcting this psychological absurdity, we do justice to the fact that the activity of painting a picture or carving a figure is no more and no less emotional than that of solving a mathematical problem. If art is singled out as emotional, this is meant to account for its emphasis on what I referred to as expression. An example will make the point. There is a painting by Rembrandt portraying an engaged couple. It conveys all sorts of information about Dutch customs and costumes. Viewed as an artistic statement it can be described as a pattern of dynamic strivings. The young man seeks contact with his bride, his eyes turn toward her, his right hand touching her breast provokes an ambivalent response as the woman reaches for his hand to keep it chastely away but actually endorses his gesture, guiding him to her body and accepting him as her mate. At the same time, her eyes focus beyond the present scene upon the future, which is being determined by what is happening now, and her other hand covers her womb, which will bear her husband's child.

In terms of formal relations, all these gentle gestures add up to a network of visual arrows, which stand in this case for the human experience of tenderness, desire, modesty, timidity, etc. But not all works of art represent human beings. Landscapes or still lifes point to different connotations, and abstract compositions suggest no such specification at all. What they all have in common is the language of art, namely the dynamics of directed forces made visible to the eyes. By a skillful embodiment of these dynamic forces the artist makes his statement. Correspondingly, every capable art teacher guides his students right from the beginning to the means of dynamic expression. And to look at art sensibly means to surrender to the guidance of dynamic form.

What is so valuable about perceptual dynamics as to make it the principal instrument of

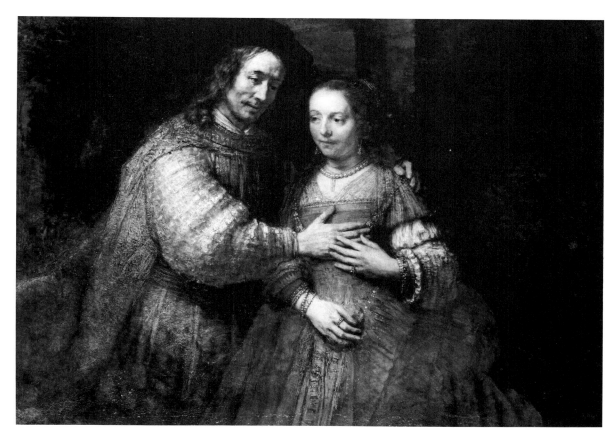

Figure 4. REMBRANDT HARMENSZ VAN RIJN (Dutch, 1606–1669). *Portrait of a Couple Dressed as Isaac and Rebecca*, 1665. Oil on canvas. Amsterdam, Rijksmuseum C216.

artistic expression? Three of its main virtues need to be mentioned here. First, the play of forces leads beyond any particular subject matter to what underlies them all. Physical forces characterize the elements of wind and water and fire. They therefore convey life to the images of nature, to the clouds, the waterfalls, the storm-tossed trees. Physical forces also animate the bodies of animals and humans. Perceptual dynamics, however, reaches further; it represents in addition the forces of the mind. And just as the physicist and the chemist come to understand nature by studying the behavior of physical forces, the psychologist and the artist grasp the workings of the mind by probing its dynamics.

Perceptual dynamics serves a second essential purpose. Since forces act the same way in all realms of existence, dynamic performance in one realm can be used to symbolize that in another. From childhood on, we are accustomed spontaneously to think and speak in metaphors because the concreteness of events that can be seen serves to illustrate the dynamics of other events that are less directly visible. When unhappy king Sisyphus heaves a rock up the hill, he symbolizes any fruitless effort, mental or physical; and perhaps the most fundamental fact to be understood about art is that whatever it shows is presented as a symbol. A human figure carved in wood is never just a human figure, a painted apple is never just an apple. Images point to the nature of the human condition by means of the dynamics of which they are the carriers.'

A third valuable property of perceptual dynamics derives from a psychological phenomenon that may be described as resonance. When one looks at the image of a rising arch or tower in architecture or at the yielding of a tree bent by the storm, one receives more than the information conveyed by the image.

The dynamics transmitted by the image resonates in the nervous system of the receiver. The body of the viewer reproduces the tensions of swinging and rising and bending so that he himself matches internally the actions he sees being performed outside. And these actions are not just physical gymnastics, they are ways of being alive, ways of being human.

What I am saying in praise of dynamic expression will be convincing to those who know its virtues from their own experience. But to many people such experience is rare, not because their nature is deprived of it but because a life concentrated on practical tasks and gains has suppressed these spontaneous responses. They may believe that even without the cultivation of artistic expression an education may be quite complete. In reply, I believe one can do no better than raise a question that is explicitly asked by few persons but is implicitly faced by everybody sooner or later. It is the question of the ultimate goal of life. The practical objectives of doing a useful and gainful job, acting to the benefit of others, and entertaining oneself are readily defined and pursued. But there comes the time when all this seems temporary and one is faced with the revelation that the only sense there is to life is the fullest and purest experience of life itself. To perceive to the fullest what it means to truly love, to care, to understand, to create, to discover, to yearn, or to hope is, by itself, the supreme value

of life. Once this becomes clear, it is equally evident that art is the evocation of life in all its completeness, purity, and intensity. Art, therefore, is one of the most powerful instruments available to us for the fulfillment of life. To withhold this benefit from human beings is to deprive them indeed.

Intuition and the Intellect

We have briefly climbed to the highest lookout, which should incline us to turn back again to the very foundation of the subject we are considering. I have stated that a principal use of art consists in its helping the human mind to cope with the complex image of the world in which it finds itself. This helpful perception, I said, goes beyond the mere recording of optical images. It involves identification and classification; it also calls for a sensitivity to dynamic expression. This delicate cognitive activity has been called "feeling," as I mentioned earlier. I prefer to call it "intuition," and I define it as a mental ability reserved to sensory perception—especially vision—and distinct from what we call the intellect. What then is the nature of this perceptual intuition and how is it related to the intellect?

Perceptual intuition is the mind's primary way of exploring and understanding the world. Before the young mind defines its notion of what is, say, a house, it grasps intuitively something of the kind of large object that keeps presenting itself in daily experience. All those buildings look different from one another, but they have something in common, and this common character is what is apprehended intuitively by the observant mind. I call it a "perceptual concept."

Soon, however, there occurs in the child's mind an important development, which as far as we know is a privilege of humans, not given to animals. The intuitive, thoroughly perceptual concepts undergo a petrification. They become stabilized and, in the strictest sense, consist of sets of standardized traits. The young mind now acquires its first "intellectual concepts." Eventually those are the concepts aspired to by logicians and scientists, the kind of item that can be handled by computers. For any such intellectual concept, of course, the set of traits may change, in keeping with changing knowledge, but at every particular stage of the discourse the set is supposed to be stable since otherwise the concept could not be reliably handled.

Obviously, these petrified concepts of the intellect are of immense value for human thinking. But they are acquired at a price. They lack the precious conjunction of individual appearance and generalization that is in the nature of intuitive concepts. The latter possess a most desirable openness, a direct access to enrichment and modification. They are spared the finality of the intellectual concepts, which are the instruments of abstract thought.

Let me illustrate the difference with an example. Suppose that while looking through the bedroom window in the morning I discover among the green and brownish bracken a single, orange-colored flash, shaped like a chalice and perched on a tall stem. I immediately recognize it as a flower and almost as directly as a wood lily, but the lively sight also remains free of its intellectual label. It preserves the spontaneous uniqueness of its appearance, receptive to all sorts of further associations. Now I open the guide book and I read: "*Wood lily*: Brilliant orange to scarlet, upward-facing, spotted blossoms. 1-3 feet. Sandy or acid soil, meadows, wood openings. Two varieties: (1) eastern form (lilium philadelphicum) with leaves in whorls; (2) western form (lilium andinum) with leaves scattered along stem." The appearance has stopped, the image has become rigid, the dynamics of shape and color is no longer discernible, the properties have been reduced to a few. I have also profited, however. I have acquired a solid thought object, a thing I can safely handle and talk about.

Quite obviously, the two resources of human cognition, perceptual intuition and the intellectual standardization of concepts, require each other. The scientist must preserve a fresh view of the phenomena he is investigating to protect his concepts against "premature closure." The artist, in turn, must understand the general significance of the objects and events he is depicting so that his work may amount to more than an accidental apparition. When in the nineteenth century one French artist said of another, "He is only an eye, but what an eye!" he praised his colleague for the acuteness of his observations but noticed at the same time that the artistic results lacked deeper meaning.

This interdependence of intellect and intuitive perception is of fundamental consequence for general education. It demands not just that in the curriculum the subjects cultivating the intellect must be properly balanced against others that train intelligent vision. More importantly, it demands that in the teaching and learning of each subject both the intellect and intuition should be made to interact.

Artwork as a Helper

In our particular field of interest this raises the practical question: How are the arts to be taught if, beyond promoting particular skills and knowledge, they are to do their share in perfecting the human mind in all its propensities? In what ways can the arts be expected to further other fields of study, such as the sciences? And conversely, how can work in fields outside the arts contribute to making the study of the arts richer?

We approach an answer when we remember that there is hardly any teaching and learning in any field of study without the practical use of imagery. There are, first of all, the infinitely many photographs and realistic drawings, paintings, and plastic models intended to provide the sight of things that cannot be looked at directly. Botany and zoology rely on the pictures of plants and animals that otherwise may be inaccessible. Dictionaries illustrate the objects and portray the persons they list and describe. Medical texts show organs, surgical techniques, the symptoms of diseases. In the field of communications, news photographs have become the universally accepted companions of verbal reporting.

But not all images have to be realistically faithful to be useful. On the contrary, they may have to be kept at a highly abstract level. Maps or statistical charts are obvious examples. By eliminating all specifics they concentrate the user's attention on the few facts that matter. A geographic map retains little but the spatial relations between the towns and roads and waterways we see. A chart depicting the rise and fall of employment over time shows no workers and no factories. And a model of the human nervous system may consist of little more than a figure made of glass and filled with a network of colored threads.

Examples such as these indicate that images produced for practical purposes have more sophisticated functions than that of supplying faithful duplicates. I mentioned earlier that in the visual arts, paintings and sculptures done in a realistic style must nevertheless display formal patterns conveying symbolic meaning if they are to meet their function as art objects. Something similar is true for technical illustrations. It is well known that for many such purposes the handiwork of artists is preferable to photography, and that when photographs are used they are often simplified and sharpened by retouching. The reason is that what an illustration needs to show is not an object as such but some of its significant properties. A good anatomical illustration is a teacher. It shows not simply the agglomeration of muscle

and bone that might strike the eyes of the uninitiated onlooker, but it also clarifies the functional interrelations among the various components that make the body move. The same is true when drawings are supplied to explain the use of engines or other contraptions.

The visual pattern revealed by the draftsman in the shape of a depicted object is an abstraction, and as such, as we already know, it describes more than the nature of the individual object and more even than that of the kind of object shown. It may clarify structural relations that in and by themselves are not essentially visual, as exemplified by the diagrams to which I referred. Diagrams illustrating logical or social relations, scientific correlations, or business organizations translate abstract networks into directly visible and therefore more readily understandable perceptual patterns.

One consequence of this intimate connection between vision and abstraction is that the studio practice of art can be directly helpful to someone coping with compositional problems in entirely different areas. Students struggling with the problem of how to organize a large piece of writing—a dissertation, a scientific report, a legal brief, or a play—might be substantially helped by learning to organize a piece of sculpture or a painting or by studying compositions created by artists. Structural problems transcend particular disciplines. By coping with them on the more tangible terrain of perceptual organization one can become more skillful in tackling organizational problems elsewhere in life.

But what exactly enables the instruments of art, the pencils and brushes and chisels, to handle problems of abstract structure? And what are the ways of teaching art that lead students to such achievements?

What to Teach and How

T raditionally, the function of the art teacher was limited to developing the manual and visual skill of the students who learned to draw accurate shapes and to copy the appearance of plaster casts or fruits or landscapes correctly. From this insistence on a flawless product, pedagogy switched in our century to its very opposite. Especially at the level of the elementary grades, it became the teacher's task to stimulate the natural impulse lurking in every young mind, the desire to make things, to explore things, to handle materials. In opposition to the tradition, it was now felt that the result of the work mattered less. There were no standards of correctness or excellence to be met and no rules to be obeyed. Whenever the initial impulse to create ran out, the child was welcome to abandon the product at any stage of completion.

This new freedom was of enormous value for art education. It changed learning from a mechanical drill to the development of the finest strivings of the young mind, giving it a chance to operate in ways congenial to its own inclinations. After this revolution, art eduction has never been the same and, one hopes, will never go back to the mechanical copying of objects practiced so commonly in the past.

It was felt by many that the new educational approach was particularly suited for the teaching of art, and this for several reasons. Artwork could be undertaken with a minimum of techniques to be acquired. Whereas neither reading nor writing, neither arithmetic nor piano playing, was possible without considerable learning of standard skills, children often took to painting or modeling without any encouragement or instruction and developed their work all by themselves with admirably fresh and beautiful results. Also, the arts were unique in not prescribing any one correctness of performance and representation. There were as many valid ways of making a clay figure of the human body as there were minds to invent them. Thus no standards needed to be imposed. And furthermore, the skills of art seemed less indispensable. While youngsters were handicapped if they could not read and write, there was less obvious harm if their sculpture was not up to snuff.

By now, educators are beginning to see that art cannot claim any privilege as to sensible teaching methods. Good teaching makes for good learning in more or less the same way in all fields of study. Mechanical drill needs to be replaced everywhere with the nurturing of

spontaneous although directed impulses. Good work in biology or mathematics is done when the student's natural curiosity is awakened, when the desire to solve problems and to explain mysterious facts is enlisted, when the imagination is challenged to come up with new possibilities. In this sense, scientific work or the probing of history or the handling of a language is every bit as "artistic" as drawing and painting.

On the other hand, the acquisition of appropriate techniques and the insistence on acceptable results are as necessary in the arts as they are in the other areas of study. As in any of these other fields, however, factual knowledge has to be introduced with much sensitivity. If it confronts the students at the wrong time, it may be meaningless and useless. It may not fit what they need and can understand at the particular stage of their development, and if it is imposed by force, it may act as a disturbance and arouse resistance. Just as it takes sensitivity for the teacher of mathematics to know when to move from the concrete numbers of arithmetic to the abstract quantities of algebra, the art teacher must sense when figural representation can be replaced with nonobjective "design," or vice versa.

Art teachers are easily tempted to teach their students tricks such as central perspective as soon as possible. It makes the teacher look professional, it pleases the student who wants to emulate adult standards, and it impresses the parents. But all too often it amounts to clumsy brainwashing. It ignores the fact that central perspective is, as I mentioned earlier, a very special formula that emerged in the fifteenth century for the first time, namely, when the intuitive search for a new centering of shapes in the depth dimension had reached a stage at which the geometrical technique came as the final logical consequence. It came as the intellectual upshot of a long intuitive search. Geometrical depth representation should not be brought into the art room before the intuitive exploration of the third dimension has readied the student's mind for the intellectual rule.

When the teaching of techniques and facts is suitably fitted to the students' stage of development, it is as indispensable to art education as it is to work in the sciences. It is also valuable to insist that a project, once undertaken, should be carried as far as the given conditions justify, provided it was chosen or willingly accepted by the student in the first place. Such a discipline is not an unwarranted imposition. Anybody who has observed even young children spending long periods of time on some challenging piece of construction or deconstruction knows that there is no end to patience, once the goal is sufficiently attractive.

To be sure, a piece of work may have to be left incomplete because it turns out to be infeasible—even great artists cannot help doing this at times—but to give it up just because nothing stronger than a flighty whim motivated the work makes for bad education. The discipline needed for the completion of the tasks of life must be trained from the beginning.

Consider here also that neither the student nor the teacher can judge what result has been achieved unless the work has been completed. The satisfaction of success is withheld if no effort has been made to attain it; and one cannot learn to do better if one lacks the opportunity to see that one has failed.

Visual Tools of Art

I n the arts, therefore, just as in other work, definite results need to be accomplished; —— and this brings me back to the question: What do the arts have to achieve if they are to contribute their share in perfecting the human mind in all its propensities? To limit the discussion, I will not consider the subjects and themes to be represented in works of art but only the visual means that bring these representations about.

I am insisting on this procedure because it is in the nature of art, as distinguished from other activities, that whatever knowledge and thought the artist—be he a child or a professional—invests in his work must serve as material or ingredients for the shapes and colors produced in the studio. As far as the arts are concerned, the creation of studio work is the ultimate purpose, one not pursued anywhere else. Whatever riches the mind contributes need to be metabolized into those meaningful creations that are nourished by all the many things their makers have ever known or felt or learned. For this reason, the art educator must be concerned first of all with what has sometimes been called "the language of art," namely, the visual tools of artistic expression.

Shapes and colors depict the objects to be seen in the work and also the spatial relations among the objects. It is these spatial relations that symbolize the physical, psychological, or logical relations to be represented in the work. At early stages of conception these spatial relations do not reach beyond the confines of the single object. The young child does observe in his drawings the relations between head and trunk or among the branches of a tree, but the object taken as a whole still may float in the nowhere. This is also the case, for example, in many of the paleolithic rock paintings. The single figures are rendered with much skill, but they may not refer to each other. They often ignore each other or overlap as though the mutual interference did not matter.

At a higher level of conception, the objects dwell in a shared space. Controlled distance indicates the difference between things belonging together and being separate. They may reach for each other or attack each other. They may add up in orderly sequences or interfere with one another. There are visible causal relations, showing the effect of one thing upon the behavior of its neighbor. Similarity of shape indicates connection, and size differences create hierarchies. In painting, the extension into the depth dimension involves the viewer in the

spatial context by creating the difference between near and far. What is near is strong and important and addresses the viewer more directly than what is distant.

A similar language of relations is available for color. When colors resemble each other they express connection, when they differ they disconnect. Harmony and disharmony convey an obvious symbolism, and complementarity makes for a remarkable combination of contrast and mutual completion. Pure colors promote isolation while color mixtures can create bridges between areas.

At a more complex level, the composition of shapes and colors organizes the structure of coherent wholes. To the best of my understanding, the variety of compositional patterns is derived from one basic scheme, namely the interaction of centric and eccentric forces or vectors. Whatever kind of art one looks at, one can observe a fundamental affinity of all visually presented forces with the center of the composition. Sometimes that center is stressed by a particularly important figure, to which the less important ones are meaningfully subordinated. This is true, for example, for many medieval altar paintings. Or the center of the composition is left empty but the subject matter provides lateral centers of its own, which are balanced around that empty center. In the representations of the Annunciation, the Virgin seated on one side of the picture is frequently balanced by the angel on the other side—balanced around the center of the composition.

This centric tendency, however, is counteracted by a second tendency, which I call the eccentric one because it refers not to the internal center of a compositional system but to external centers, of which a principal example is the force of gravity—the basic force that pervades the physical world as well as the world of artistic representations. Although all things on earth are organized around their own centers, they are attracted also by the outside force of gravity centered in the middle of our terrestrial globe. To find the proper equilibrium between the internal and the external centers is an essential task reflected in every pictorial composition.

I mention this compositional scheme because it can also serve as an example to show that the structural patterns that organize works of art have a more general application in other fields. Of particular importance is the fact that the interaction of centric and eccentric forces is fundamental also to the dynamics of human motivation. Psychologists observe forces directed towards the mind's own center, egocentric or inner-directed ones, and distinguish

them from those controlled by outer powers, centers that generate responses such as love and fear. The proper interaction between centric and eccentric forces might be considered the basic problem to be solved by what we call the conduct of life.

This structural analogy enables the formal appearance of works of art to serve as a visual symbol of the experience of life. The artist offers concrete clarified images of much less tangible forces that we know as human wishes, hopes, aspirations, fears, and so forth. Translated into patterns of shapes and colors, they face us as reflections of our own nature more articulately and impressively than we may have known ourselves from direct experience.

The forces managing the individual mind are not the only ones symbolized by artistic composition. The behavior of social groups and political entities is equally governed by the interaction of centric and eccentric forces. So are certain physical constellations, such as those ruled by gravity or magnetism. Similarly, other, more specific types of structural relations apply in all areas of knowledge. A diagram illustrating the organization of a government or a business relies on the visual devices by which an artist depicts a hierarchy. Topological relations such as containing, overlapping, and mutual completion are studied by mathematicians, logicians, philosophers, and social scientists with the help of the appropriate visual shape patterns.

Materials Have Character

The materials and vehicles used for artistic activity also have distinct character traits to which one responds somewhat as one person responds to another. One is attracted by some, repelled by others, and indifferent to many. There is, for example, the difference between the directly sensory and the verbal media. Verbal language is an indirect medium because it deals with its subjects by means of auditory and visual tokens or signs that do not generally depict qualities of the subject. They are essentially arbitrary shapes on paper or sounds to which meaning is assigned by convention. These meanings of words are generic concepts, not individual appearances. All this indirectness and abstraction suits an attitude of thoughtful detachment. The painter or sculptor faces his subject, the writer thinks about it. It is true, of course, that verbal language also has strong sensory qualities, such as the auditory expression of speech, which makes possible the creation of almost musical relations between pitches, vowels, and other speech noises, as well as rhythms. Visually, the arrangement of words on a rectangular piece of paper contributes to the messages of poetry, posters, or advertisements.

At the opposite pole of artistic expression, we find the closest connection between the maker and his subject when he represents it in a performance using his own body. Dancing and acting are probably the oldest media, derived from the spontaneous manifestations of states of mind. The body makes a person look happy or sad, vigorous or weak, and gestures are a prime means of communication. The making and handling of objects comes later, is less spontaneous, less personal. Even in music, there is probably a psychological difference between singing, a direct emanation of the person, and the playing of an instrument such as a piano, which is a detached object. The most indirect art medium is photography, which delegates the shaping of its objects to a machine, even though it is by no means a mechanical occupation.

Among the art materials, we distinguish, first of all, between touchable and untouchable ones. Think of light, a purely visual phenomenon, which is manipulated, however, by the architect to articulate spaces or by the stage designer to create the mood of a scene or to direct the audience's attention. Recently, the techniques of fireworks and military searchlights have been developed by artists to use the sky as an arena for plays of projected lights.

Figure 5.
OTTO PIENE
(German, 1928–).
Anemone, 1978.
Polyethylene and sailcloth.
National Mall, Washington, D.C.
Photo: Elizabeth Goldring.
Reproduced by permission of
the artist.

How different is the experience of directing remote apparitions of light from the sturdy craft of the sculptor, who confirms every visual observation with the touch of his hands! In the sculptor's work, the most significant difference psychologically is that between modeling and carving. A soft material like clay, too pliable and characterless for the taste of some users, serves to build an intended shape, a technique readily accessible even to children. Adult artists often seek the challenge of materials like wood or stone that must be conquered by cutting and hammering and that oppose the will of the artist with the character of their own physical structure. There is also a curious paradox about carving, in that the intended shape, for example, a figure, is not built, as in modeling, but is liberated from the block of material, in which it seems to be hidden. The carver's manual labor applies negatively to what does not

belong and must be taken away; it is a kind of rescue operation, involving a sophisticated relation between conception and execution.

The flat surface of a canvas or piece of paper offers a condition quite different from the sculptor's block of wood or stone. It is virginal rather than pregnant, its emptiness makes the demand of creating something from nothing, a task frightening to many. At the same time, it also offers an unlimited freedom, a total lack of opposition, which can be experienced as an exhilarating opportunity, not frequently offered in other life situations.

The all-too-brief character sketch I have given here of the materials that determine the nature of the media pretends in no way to be exhaustive. As I mentioned, it is simply intended to remind the educator that the physical conditions of artwork are accompanied inseparably by psychological connotations that must not be overlooked when it comes to deciding which child, which student, should be encouraged to undertake which kind of task.

Applications Elsewhere

Artists spend their professional lives on the study of visual structures. They are the experts on what one might call the resources of visual language. It is sensible, therefore, to conclude that the study of art should be an indispensable part of the training in any other field of knowledge. The gain from such a study of art is not limited to a greater skill in the making of diagrams, charts, and other illustrations. After all, these visual aids are nothing but the reflections of the thought images by which the scientist, the economist, the surgeon, or the engineer conceives of his work and develops his theories and strategies. A practical acquaintance with the principles of artistic form and the ways of conveying meaning by way of these principles contribute therefore directly to the training of productive thinking in any field.

I know of a dental school where some studio work in modeling and carving is a required part of the training program. The usefulness of such a practice is obvious if one considers that the ability to understand the shape of a tooth as a three-dimensional structure is an indispensable prerequisite for knowing how to deal with the case of the individual patient. What is the spatial relation of the diseased tooth to its neighbors? How can I reach the cavity with my tools, and how does the mirror image correspond to the actual shape? In the sculpture studio, one learns how to integrate the partial views of a cubic object in a total overview and how to perceive an arrangement of units as a network of spatial connections.

To pick another example at random: studies have been made to show how geographic maps interact with political strategy. It makes a practical difference whether politicians view the American continent as the western border of a ring of countries that surround the Atlantic Ocean or whether they see it as a kind of central intermediary located between Russia and the Far East to the left and Europe to the right. Or: the North Pole, which used to be tucked far away from the traffic of international relations, has recently become a center of important economical and political connections. This sort of restructuring of visual constellations closely resembles the daily practices of the artist.

To be sure, artwork can fulfill this useful purpose only when it is properly taught. I referred earlier to the one-sided approach of art educators who put their entire trust in the spontaneous inventiveness of the unspoiled mind and are reluctant to promote any systematic

Figure 6.
Political map
from *The Geography of Peace*
by Nicholas John Spykman *et al.*
©1944 by Harcourt Brace
Jovanovich, Inc.
Reprinted by permission of the
publisher.

development and any striving toward completion of the work. From that point of view one might object to what I am advocating here because it may seem to reduce art to the handmaid of other occupations. Art would become a mere trainer for skills needed elsewhere. This, however, is a misunderstanding derived from a lack of appreciation of what is needed for truly creative and fruitful artwork.

At no level of development can either children or accomplished artists state, to their own satisfaction, what they want to say unless they have acquired the means of saying it. In the beginning, these means are simple, and, as I urged earlier, no attempts should be made to foist upon the learner technical tricks that go beyond his or her stage of conception. Nor should the means of visual expression be taught as isolated devices. The need to master them should naturally emerge from the demands of the task, and whenever possible the learner himself ought to be made to discover them by himself rather than have them supplied by the teacher.

Most importantly, the task should always be an artistic one. It consists, as I suggested earlier, in giving visual expression to a significant form of existence or behavior by means of the properties of shape, color, etc. Indispensably, the study of art should aim at art from the beginning and at all times.

This will do no harm to students who take studio classes just for the acquisition of skills needed for other fields of work. It will add another humanly desirable dimension to their scientific or technological orientation. But clearly in this discussion the difference between science and art should not be blurred.

For our purpose, the following distinction between science and art is essential. Much of science and technology uses visual images only as a means to an end. Scientists are concerned with the exploration and application of physical or mental forces. To find out how these forces work, they use visual images, whose behavior serves as an analogue for that of forces that are not directly perceivable. One cannot see electricity or gravity or the Freudian libido, but one can see arrows or enclosures or concatenations. A scientist will look at a drawing of a microscopic section or at the diagram of an Australian tribe's social constellation, and if the picture points clearly to the essentials, he will be grateful for it. But it is not the picture he is after.

In the arts, on the contrary, the image is the final statement. The image is where the attention stops because it offers the live presence of what the viewer recognizes as an essence of human experience.

Resources to Draw On

M ost man-made images involve elements of artistic expression, even if they are not made for that purpose. Then again, even when they are made as works of art, they can be used as resources for nonartistic explorations. The treasures of art history yield much factual information. One can study the statues and wall paintings of the ancient Egyptians to trace the conception they had of their rulers or of the social position of women, craftsmen, or prisoners of war. One can scrutinize Renaissance portraits in search of medical symptoms: goitrous necks, arthritic wrists, lips deformed by inbreeding. One can find in Nazi sculpture the visual manifestation of the personality traits they considered ideal or the body build they thought beautiful.

These are perfectly legitimate uses of works of art, as long as the purpose remains clear. In the field of art history, a great deal of research has no immediate reference to the artistic qualities of art objects. Who commissioned a particular altar painting? What philosophical tradition or theological doctrine determined the theme of a particular mural? What childhood experience of the artist is responsible for the particular slant he gave later to his depiction of the relation between mother and child? All these questions may be aimed merely at the subject matter of painting and sculpture without explicit reference to their qualities and functions as works of art. Even so, the facts established in this manner can be used to further the understanding of art in general and individual works in particular.

The value of such supplementary information has been denied by some theorists. They have maintained that since the aesthetic effect of works of art is transmitted by the visual expression of their appearance, nothing but the shapes and colors of the image should be considered the legitimate properties of the work. Whatever the psychological or historical value of knowing the factors that led to the work, they could only distract from the artistic experience generated by the work itself. Such a view is clearly mistaken. To be sure, one must never lose sight of the primary role of visual expression. But, as I pointed out in the beginning, sensory perception is inseparable from the contributions of memory, organization, and concept formation. The visual expression of a human figure is fundamentally influenced by what the viewer knows about human beings. A viewer who knows nothing about the story of the judgment of Paris and the nature of Greek mythology in general may

Figure 7. PETER PAUL RUBENS (Flemish, 1577–1640). *Paris Awards the Golden Apple to Venus* ("The Judgement of Paris"), 1632–35. Oil on canvas. London, The National Gallery C194.

feel profoundly touched by the mere image of the three female figures grouped by a great artist and placed in significant relation to the young man watching them, but this same image will be infinitely enriched by whatever knowledge the viewer has of the story and of the culture that produced it.

Anybody comparing paintings by Rubens and Rembrandt will be impressed by the difference of the worlds that face him in the work of these two artists, who were so closely related in space and time. It is most helpful to know that one of them was in the service of a traditional feudal state whose rulers were surrounded with the wealth of Roman Catholic imagery, while the other knew Protestant frugality but also the new prosperity of a

democratically organized middle class of merchants. These connections between background of knowledge and foreground of vision are not automatically evident. They must be explicitly made. I am reminded of the gallery instructors at one of our finest museums who had been carefully trained with a good deal of historical and technical knowledge pertinent to the great paintings and sculptures to which they introduced the public. Yet their efforts often failed to be truly successful, for the reason that the facts they reported did not obviously relate to what faced the visitors in the works themselves. Stories about an artist's life and patrons and about the economic and political circumstances of his time, while quite pertinent, distracted from the visual experience because they were not directly evoked by it. I remember watching a group of visitors so fully absorbed by the visual eloquence of a painting on the wall that they lost track of the speech of their guide, who desperately clapped her hands, exclaiming, "May I have your attention, please!"

All sorts of interesting things can be discussed apropos of art without serving art's purpose. But whenever the discussion is clearly intended to enhance the experience and understanding of art, as, for example, during a visit to a museum or in a school class devoted to art, it should take off from what can be seen in a particular work—seen, in fact, in the particular sense of the expression conveyed by the composition. The mood of depravity emanating from Van Gogh's painting of the night café in Arles may be shown to be created by the desolate quality of the interior, the isolation of the figures, the sinister play of the reds and greens. To support this visual impression, the teacher may want to quote Van Gogh's letter to his brother, in which he describes the experience he wanted to reflect in this painting. From this particular instance, the discussion may broaden to include the circumstances of Van Gogh's life that manifestly affected his paintings and drawings.

What I am trying to stress is that in any such subsidiary discussion the instructor's attention ought to remain trained on the direct visual perception, the eye contact with the work of art, informed by the students' own studio experience and their exposure to the artwork of others. The direct artistic experience is what makes art worth talking about. I am insisting on this because the temptation to focus instead on some other property of artwork is strong and widespread. Artistic experience is difficult to talk about, difficult to nail down, difficult to assess. It is much easier to analyze subject matter historically or psychologically, and therefore many a teacher and scholar will limit his entire activity to it. Nothing is wrong with that, since the results of such exploration can be valuable, as long as it is understood to be

Figure 8.
VINCENT VAN GOGH
(Dutch, 1853–1890)
The Night Café, 1888.
Oil on canvas.
New Haven, Yale University Art
Gallery.
Bequest of Stephen Carlton
Clark.

devoted to history or psychology, not to the study of art. Mislabeled, it will contribute to suppressing rather than promoting art education.

I tried to show earlier that in our Western tradition the nature of art has been commonly misinterpreted as being nothing but an enjoyable entertainment and that in consequence it has been demoted, at least since the Renaissance, to a means of diversion and decoration. In the schools, this has led to a neglect of art education. Verbal and numerical skills have come to dominate the curriculum. All attempts to remedy this crippling situation must start out by rectifying the popular notion of what art is about. The reform must reinstate the priority of artistic experience and must make it clear that this experience is limited neither to sensory enjoyment nor to "emotional" relief. It must insist that the way to make art educationally respectable is not to move away from aesthetic experience to the practicing of skills indigenous to other fields of study, but rather to enlist the various areas of human knowledge for the broader and deeper understanding of what is specifically artistic.

This is more easily accomplished in the early years of schooling. The supplementary resources accessible to the young mind are fairly simple, and since one teacher is in charge

of all the instruction, the integration of studio experience with outside materials can come about quite naturally. The simple shapes and colors characteristic of the children's own work are easily related to similar styles in folk art or tribal art. Such affinity of visual conception can lead the teacher to talk about some of the social and religious functions of such work in other cultures, and it takes neither an anthropologist nor an art historian to do so. It is not beyond the teacher's competence to talk with the children about the bark paintings of the Australian aborigines. Not everywhere, she will explain, do people have paper. On whatever material they can prepare, they tell of their concerns and beliefs. Without much detail, they describe what matters most about boating and hunting. The kangaroo, an essential resource of food and material, is shown from the outside and the inside of its body, and the gods and demons of their religion become visible in their pictures. The kinship between the simply shaped but impressive and beautiful paintings of a distant race and the children's own artwork is established without effort.

Such integration of experience and knowledge becomes more difficult in the years of secondary and higher education. Different fields of study are taught by different instructors, who usually have no way of coordinating their approaches. Whatever relations exist between what is being presented in different class settings must be discovered by the students themselves. This is least problematic when the subject matter is closely related, as, for example, in the connection between studio work and art history. Even so, art students frequently complain that an entire course on, say, the history of Baroque sculpture may be taught by an instructor who is knowledgeable enough about the seventeenth and eighteenth centuries but has never handled clay or marble himself and therefore does not interpret the works shown on the screen in the terms most naturally accessible to the students. At the same time, however, art history courses taught by painters or sculptors may suffer from a lack of objectivity and solid information.

Figure 9.
Ubar Kangaroo
(Gunwinggu, Australia).
Canberra, Australian Institute
of Aboriginal Studies.

Content and Meaning

Art schools, in particular, offer a challenging opportunity for humanities courses geared to the special outlook and experience of art students. But not many instructors are prepared to meet these special conditions. A case in point is the study of the psychology of visual perception in its relation to art. An instructor, teaching such a course in a fashion generally accepted in psychology departments, may begin with a detailed analysis of the optics and physiology of the eye and then follow the optic nerve by way of the chiasma to the cortical projection centers of the brain. He may then turn to the Weber-Fechner law of light thresholds or to the statistical results of experiments on shape constancy. By that time he may have lost the attention of his students for the rest of the term. Instead, a course designed with a view to its particular audience may take off from the visual phenomena familiar to the students: shape and color, light and spatial depth, motion and the dynamics of expression, using plenty of artworks as examples and reporting on experimental findings pertinent to the visual effects that have been observed on the screen.

Some years ago, the president of a midwestern art school consulted me on what courses I thought most suitable for the humanities program to be taken by his students in addition to their studio work. I told him that a course in mythology would be my first choice, with Ovid's *Metamorphoses* as the principal item on the reading list. I suggested this topic not only because it would offer his students an inexhaustible supply of colorful subject matter— stories that the artists of past centuries knew from their nursery years and that have all but disappeared from the reservoir of our students' imagination. Nor did I recommend this magnificent store of themes simply because it would give the students access to innumerable masterworks of art history, from the Greeks and Romans all the way to Picasso. My main reason for the suggestion was that the mythological subjects offered the best possible demonstration of the most fundamental fact to be understood about art, namely, that art cannot be about nothing.

It is in the nature of mythology that its stories are symbols of basic human experience and that they transmit their underlying theme with an immediacy nobody can miss. The labyrinth of Crete, for example, is the unmistakable symbol of imprisonment in an undecipherably mysterious world; Icarus's flight toward the sun embodies the mortal danger

of human hubris; and when Daphne is turned into a tree, the basic distinction between being human and being a plant becomes evident. Such examples cannot fail to show the attractiveness of subject matter that is transparent with meaning. They inspire the user to handle his shapes and colors in ways that will bring this meaning to the fore; and once meaning becomes indispensable, the young artist will no longer do without it. Even in abstract art, there is a decisive difference between works that amount to nothing better than a play with visual effects and others that speak symbolically of significant experiences. It seems to me essential to stress this point because the present art scene suffers from the emptiness of too many of the works it produces. There is too much handling of shapes for shapes' sake, too much triviality of subject matter, such as soup cans or comic strips. In the still lifes of a Chardin or Cézanne or Morandi, ordinary household ware becomes eloquent, and only this transcendental quality makes it suitable for being used by a thoughtful artist.

The history of art shows that successful art has never been devoid of significant content. Often this content was supplied by the religion or the philosophy of the times, and even when artists did not have much schooling, as was often the case, they tended to give intelligent thought to what one might broadly call the facts of life. Such thoughtfulness is likely to be impaired when the cultural climate is devoid of spiritual values, as is our own; hence the abundance of works that testify to much visual talent and skill but also to a deplorable shallowness of mind. A principal mission of art education is to counteract this cultural drought, a task that depends largely on the spirit that guides the work in the art room itself. But the same thoughtful intelligence must be applied to the resources brought to art instruction from other areas of knowledge. Otherwise even mythology can be presented as an assortment of irrelevant stories left over from ancient times that no longer concern us. Under such conditions even Ovid will lose his power of enchantment.

What I have said in this section is best exemplified by the needs of teaching in art schools and colleges, but it applies equally to art education at the primary and secondary levels. There, too, subsidiary instruction intended to supplement studio work must be geared to the particular visual approach and there, too, food for the visual imagination can be drawn from such sources as great literature. Beginning with the early school years, the decline of traditional imagery and its spiritual meanings must be counteracted by the teacher's awareness of the arts as instruments of thoughtfulness.

No Art without Function

 uch of what has been said here concerns the relation between artistic and nonartistic functions of manmade objects. It is a relation that must be faced squarely also in the so-called applied arts, which combine practical purposes with aesthetic ones. All too often, these two kinds of function are considered separately as though they had nothing to do with each other. A building, for example, must be suited to house and protect its inhabitants. The architect's design must serve these functions. But the building should also look attractive, inviting, dignified, or whatever its intended character. These aesthetic properties, too, make demands on the design. As long, however, as the two functions are considered separately, there is no obviously satisfying way of combining them. At best, they do not interfere with each other. More often, this misleading conception produces designs in which practical function and ornamentation clash, upsetting the visual unity of the building.

What is the solution to the problem? I believe that a sensibly trained designer comes to think of the practical function of a building or other useful object the way a painter thinks of the subject matter of a picture. The design must not only meet the practical requirements of the object, it must also represent and interpret them. Take the example of a chair. Its shape must be such as to facilitate sitting. But what kind of sitting? The customer may want to indulge in a maximum of physical surrender, calling for cushioning and yielding and softness, as offered by an inflated tube. Or he may ask for the dignity of a throne or the severity of straight and angular chairs that keep the body in active muscular control. The form of the chair, then, is nothing but an interpretation of what is meant by "sitting." It involves a whole way of life, a whole philosophy. If at a museum you compare a graceful Rococo chair with an austere Shaker chair and Mies van der Rohe's elegant Barcelona chair, you will find that you are looking at three worlds.

Or take the example of a ceramic pitcher or bowl. Such objects combine in many different ways the practical functions of receiving, containing, and dispensing. But they also symbolize visually the different states of mind in which food and drink are taken. Remember here that not long ago the gathering at the dinner table in the American home was something of a religious ceremony. There was conscious gratitude for the life-giving nourishment received and there was the social hierarchy of the family, with the head of the household sitting at the

Figure 10.
Ludwig Mies van der Rohe
(German, 1886–1969).
Barcelona Chair.
New York, Knoll International.

head of the table and dispensing the food. A meal was a ceremony, for which one had to be properly dressed, and the furniture and tableware had to be carefully designed to suit their functions. Then again, nowadays we witness the very opposite: the consumption of food as a purely physical necessity to be taken care of as quickly as possible, with furniture and tools shaped for economy, hygiene, and practical comfort, easy to clean, to stack, and perhaps to dispose of. In good design, the object not only serves its practical function but also expresses in its visual appearance the way of life that invented it.

Studio work in architecture, ceramics, or jewelry remains a thoughtless play with shapes unless it is understood in the context of the style of life for which it is intended. A good instructor will create an awareness of this context in whatever way feasible, making sure that the social, historical, or psychological material to which he refers the students does not

merely burden the curriculum with more learning matter but adds a functionally related aspect to the design work itself.

Once the student's eyes are opened to the fact that good form is always a carrier of meaningful expression, it will also become clear that the functions expressed through shapes and colors go even beyond mirroring a particular historical and social situation. They have a more broadly human relevance. After all, functions such as receiving, containing, and dispensing or supporting and protecting are essential human activities, so that the particular form the designer gives to his building or chair or bowl depicts a particular way of coping with those human functions. The world of practical objects is revealed as a world of vital symbols, promoting thoughtful living.

This broadened view favors also a badly needed rapprochement between the applied arts and the fine arts. The pernicious distinction between the two, limited to the recent centuries of our Western civilization, has led to the notion that crafts like architecture are not quite art and that painting and sculpture are privileged to exist for no other purpose than their own sake, that is, for the mere pleasure of their appearance. In the practice of many schools, this has made not only for a harmful separation in the teaching of the two kinds of studio work, but also for the belief that the painters and sculptors are superior to the potters or the fabric designers. Actually, I suspect that in our time the painters and sculptors have found it harder to do substantial work than their colleagues in the crafts because they have failed to realize that their own conceptions also involve a practical function. I tried to point out earlier that the arts, when given a chance to fulfill their natural task, are an indispensable means of making us cope with the challenges of human experience. This is the entirely practical function of the arts, and unless it is lived up to, they cannot claim as much of a right to exist as other human activities. In other words, unless art is applied art, it is not truly art at all.

The Arts in Education

So far, inevitably, I have looked at art education somewhat nearsightedly by discussing what it can do for areas of learning outside the arts, or receive from those areas. It is necessary, however, to see our special field in its place as one aspect of general education. Where does art education stand in relation to the task of forming a fully developed person? My answer is that it should operate as one of three central areas of learning intended to equip the young mind with the basic abilities needed for coping successfully with every branch of the curriculum. The first of these three central areas is *philosophy*, instructing the student in (1) logic, that is, the skill of reasoning correctly, (2) epistemology, that is, the ability to understand the relation of the human mind to the world of reality, and (3) ethics, that is, to know the difference between right and wrong. The second central area is *visual training*, where the student learns to handle visual phenomena as the principal means of dealing with the organization of thought. The third area is *language training*, enabling the student to communicate verbally the fruits of his thinking.

These three areas constitute the service core of the educational edifice, since they supply the general equipment for what is needed for study in any particular field. Whether the work is in biology or in mathematics, in history or in engineering, basic preparation in those three central areas should be considered indispensable. The interrelation, however, works both ways, since for the teaching of the three central areas one cannot but draw on the resources of the various particular disciplines. For the teaching of ethics one may rely on examples from history or clinical psychology; for language one uses the reservoir of poetry; for the structure of visual form one goes to the history of art.

It will be noted that in this curricular scheme each of the three central subjects figures in more than one discipline. It is one thing to study the use of language as a means of communication and expression; it is another to study literature or foreign languages. In fact, those areas are commonly taught separately. A similar separation is less common in the two other areas. Philosophy as an instrument of thought is not always offered separately, in addition to, say, the history of philosophy. I think that there are good practical reasons for having them both. There is an analogous difference in the area of visual training between (a) a core course on the practical and theoretical aspects of the visual modality, for which

examples are found in the maps of geography, the diagrams of chemistry, the works of visual art, and (b) a studio course in sculpture or a survey of Greek vase paintings. In present practice, courses in basic design differ in fact from those specifically devoted to, say, architecture.

Each subject matter, then, is structured around a center of its own, be it studio art or art history, language as a means of communication or Shakespearean drama, but each area of study interacts also with the others. This network of relations is organized as a system of human experience and wisdom.

Needless to say, the educational system I have sketched as an environment for the arts is an ideal image, at present not realized at any level. But without a goal, planning for a better world has no place to go. It will also be obvious that what I have been describing refers to education as attained at a level to which the years of schooling ascend only gradually. Many a subject matter not available in the beginning is reached eventually. More importantly, the differentiation into specialized areas of work needs time to develop. The arts, at first an inseparable and loosely knitted unity of bits of skill and knowledge, split eventually into the areas of competence that cultivate particular skills and achievements.

Can Art Be Taught?

T hroughout the foregoing discussion I have tried to make clear that the active production of artwork as well as the appreciation of works of art is largely a matter of intuition, and that the cultivation of intuition is the principal contribution art makes to the formation of the human mind. It is an ability to be jealously protected. Not surprisingly, therefore, there can be considerable resistance to the kind of discussion I have presented in the present essay. Whatever homage I have offered to intuition, I had to do it by means of intellectual argument. Similarly, much teaching is done by speech, that is, by the conceptual vocabulary of language. And when I argued for the usefulness of supplementing artistic experience with knowledge from various areas of study, I advocated the employment of intellectual matter—a recommendation received with distrust especially by some practitioners of the arts.

Hence the assertion that the arts cannot be taught and that any kind of reasoning about them endangers the spontaneity of creative invention. Historically, this attitude is a fairly recent product of our particular Western culture. It was the Romantic movement that initiated a campaign against the intellect, a campaign that took various forms and attacked various targets. In our own century, objections were raised in particular to the interpretation of motivational tendencies of the human mind, practiced by psychoanalysis for therapeutic purposes. Such a treatment may cure mental troubles, some people say, but perhaps at the expense of the person's creativity. Off and on, in my own practice of teaching courses on the psychology of art, I came across students who told me that they could not continue their attendance because some of the rules and explanations I had given them turned up as disturbances during their studio work, interfering with the freedom of their intuitive decisions.

One-sided though such objections often are, they must not be taken lightly. I may be permitted here to refer to a fable written by the Austrian writer Gustav Meyrink in the early years of our century. *The Curse of the Toad* tells about a centipede who performed a graceful dance on the square in front of the blue pagoda. From a corner he was watched attentively by his jealous enemy, the toad. When the dancer took a rest, the toad approached him with a message, in which she explained that although she was clumsy and four-footed, she was

skillful in calculations. In watching the centipede's dance, however, there was one thing she said she could not figure out: "How do you ever know which leg to move first? And which one comes as the second or the seventh or the hundredth? And when you move the sixteenth leg, what does the forty-eighth do? Does it stand still, does it stretch or bend?" The centipede, after a moment of puzzlement, discovered to his terror that he was totally paralyzed. For the rest of his life, he never again was able to move a limb.

The story sounds convincing, especially to young performers. Beginning dancers and actors find that simple actions or gestures they have mastered effectively and without a thought since childhood stiffen their limbs suddenly when they are asked to carry them out consciously and according to certain rules. This intermediary phase occurs in much learning, but the gain it produces is worth the temporary frustration. Typically, the newly acquired technique drops out of conscious control and becomes second nature.

The same is true for learning about art, theoretically or practically. Throughout history, most artists have been eager to learn what they could about their trade rather than being afraid of such knowledge. Some of the best—Leonardo, Dürer, Delacroix, Klee—have taken pains to transmit in writing the principles and rules they found useful in their own work. My own guess is that the fear of being disturbed by external direction occurs in individuals in whom the intuitive impulse and control are weak or hampered by some other influences and who therefore, in fact, cannot afford any distraction. I do not know how rare or frequent is such a disposition, but it seems to me that it should serve as a warning to us educators. The growth of the young mind is at best a delicate process, easily disturbed by the wrong input at the wrong time. In the arts as well as elsewhere in education, the best teacher is not the one who deals out all he knows or who withholds all he could give, but the one who, with the wisdom of a good gardener, watches, judges, and helps out when help is needed.

For Further Study

Needless to say, the thoughts and facts discussed in this essay derive from sources that can fill a voluminous bibliography. It seemed to me preferable not to burden the text of so succinct a survey with all those references. I had to realize, however, that throughout the discussion I talk all too briefly about certain aspects of art education and psychology that can do with the fuller clarification I have given them in other books and essays of mine. Because of this close connection between what is said here and what I have said elsewhere, I am listing the principal of those resources for the benefit of readers who are looking for a more thorough exposition.

The elements of visual perception and expression, together with a chapter on the artwork of children, are described in my book *Art and Visual Perception* (1974). On the principles of composition see the rewritten version of *The Power of the Center* (1988). In an early essay, "Perceptual Abstraction and Art," reprinted in *Toward a Psychology of Art* (1966), I have given the theoretical foundation for perceptual concepts, more broadly discussed in *Visual Thinking* (1969). For a more recent formulation see "The Double-edged Mind: Intuition and the Intellect" in *New Essays on the Psychology of Art* (1986). This same book contains a paper on the applied media entitled "The Tools of Art—Old and New," a subject for which I can refer also to "From Function to Expression" in *Toward a Psychology of Art*. That same collection of essays contains my unorthodox discussion of "Emotion and Feeling in Psychology and Art."

These books, all published by the University of California Press, also offer ample references to the pertinent works of other authors, deplorably neglected in the present essay.

Rudolf Arnheim

Rudolf Arnheim, now professor emeritus of the psychology of art, Harvard University, received his doctoral degree in 1928 at the University of Berlin for work in the psychology of visual expression, philosophy, and the history of art and music. His principal teachers were the Gestalt psychologists Max Wertheimer, Wolfgang Köhler, and Kurt Lewin.

His first two books, *Film as Art* and *Radio, an Art of Sound*, led to practical application at the International Institute for Educational Film in Rome and the British Broadcasting Corporation during World War II. After his immigration to the United States he received fellowships from the Rockefeller and Guggenheim foundations and began his teaching career at Sarah Lawrence College and on the graduate faculty of the New School for Social Research in New York.

From 1968 until his retirement he taught at Harvard's Carpenter Center for the Visual Arts and thereafter at the University of Michigan in Ann Arbor. In 1976 he received the Distinguished Service Award of the National Art Education Association.